HEYDAY BOOKS BERKELEY CALIFORNIA

CONSERVATORY OF FLOWERS SAN FRANCISCO CALIFORNIA

BY NINA SAZEVICH

Treasures *of the* Conservatory *of* Flowers

PHOTOGRAPHS BY KEVIN J. FREST

Library of Congress Cataloging-in-Publication Data
Sazevich, Nina.
Treasures of the Conservatory of Flowers / Nina Sazevich ; photographs by Kevin Frest ; photographs by Kevin Frest.
p. cm.
ISBN 1-59714-031-7 (pbk. : alk. paper)
1. Conservatory of Flowers (San Francisco, Calif.) 2. Tropical plants—California—San Francisco. 3. Conservatory of Flowers (San Francisco, Calif.)—Pictorial works. 4. Tropical plants—California—San Francisco—Pictorial works. I. Conservatory of Flowers (San Francisco, Calif.) II. Title.
QK73.U62C66 2006
581.70913'07479461—dc22 2005034353

Project Producer: Lisa Van Cleef
Cover Art: Kevin J. Frest
Cover Design: David Bullen
Interior Design/Typesetting: David Bullen

Orders, inquiries, and correspondence should be addressed to:
Heyday Books
P. O. Box 9145, Berkeley, CA 94709
(510) 549-3564,
Fax (510) 549-1889
www.heydaybooks.com

Printed in China by Imago

10 9 8 7 6 5 4 3 2 1

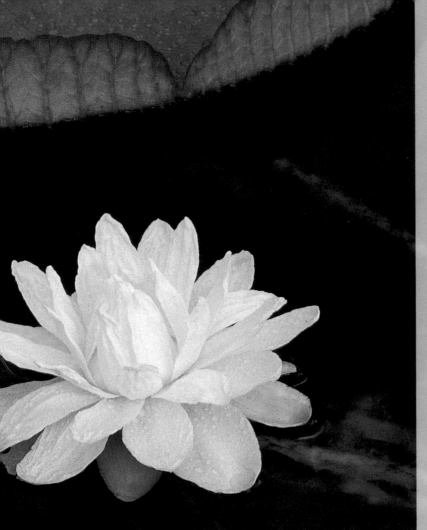

Contents

ACKNOWLEDGMENTS

The Conservatory of Flowers would like to thank the San Francisco Parks Trust and the San Francisco Recreation and Park Department. Thanks to Jim Henrich, Scot Medbury, Lisa Van Cleef, and Ann Ziolkowski of the conservatory for their work on this publication. Further thanks go to nursery specialists Clare Cangiolosi, Lupe Cota, Kristen Natoli, and Corina Rieder. Thank you to Celena Hoskins for research assistance, to photographer Kevin J. Frest for his generosity and wonderful work, and to Ron Parsons for his outstanding orchid photography. Special thanks to Jeannine Gendar, Rebecca LeGates, and Malcolm Margolin of Heyday Books.

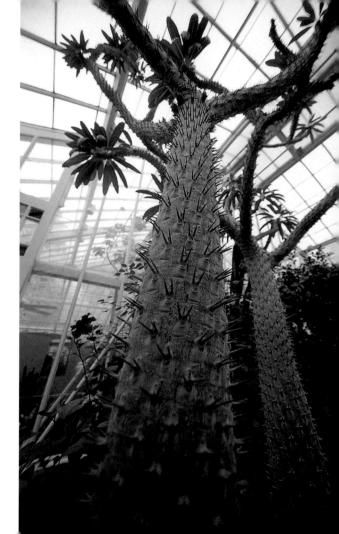

A Living Museum

Here in the warm, humid air, amongst the giant leaves of primeval plants, creeping vines, and luminous flowers floating on the surfaces of dark pools, it is easy to feel a world away. And indeed you are. From Borneo to Bolivia, the seventeen hundred species of plants at the conservatory represent unusual and often endangered flora from the tropical forests of more than fifty countries around the world.

Like a belt that wraps around the earth's mid-section, the tropics lie along the equator between the Tropic of Cancer and the Tropic of Capricorn. They include many countries in Central and South America, Africa, and Southeast Asia. Tropical forests are as diverse as the countries they grow in. Rainforests, where the rain falls year-round, are certainly the most famous, but they make up only 40 percent of the world's tropical forests. In places where the rain falls seasonally, trees that drop their leaves grow in deciduous forests, and cooler cloud forests thrive on misty mountaintops. At very high elevations, the tropics can even begin to look like the Alps, with a permanent cover of snow.

High and low, these forests teem with life. In a single hectare (about 2.5 acres) of rainforest, you would find, on average, two hundred or more species of trees, compared to only ten to fifteen species in the same area of a temperate North American forest. It is no wonder that Victorian

society went mad for tropical plants—it had never seen such a fantastic array of natural riches.

But what seemed like a boundless resource at the turn of the century has proven finite; since 1879, when the Conservatory of Flowers opened to the public, more than half of these fragile forests have disappeared. Can we reverse the trend? Perhaps we can, particularly if we cultivate a personal connection to the living things around us. So, we invite you to fall in love with our miniature jungle, to learn about its mysteries, and to be awestruck by its beauty. Maybe then, motivated in true San Francisco fashion by flower power, we can work together to conserve our tropical forests for generations to come.

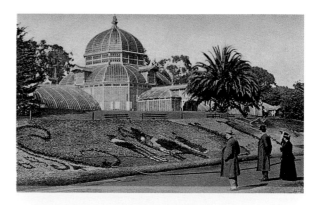

Since the conservatory opened in the late 1800s, millions of postcards bearing its image have been sent to every corner of the nation and around the world. Courtesy of the San Francisco History Center.

This Old Conservatory

The Conservatory of Flowers is the oldest surviving municipal wood and glass greenhouse in the United States. That it is made of wood and not metal is something of a distinction. By the time it opened, most similar structures in Europe were being constructed of cast iron and glass. The English had made engineering history decades earlier with the famous Palm House at Kew Gardens, using iron

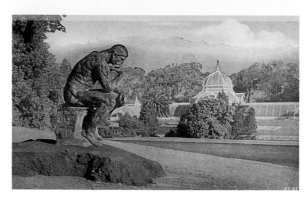

to span great widths without support beams. But cast iron did not truly take off in America until the 1880s, and in the West, where wood was plentiful, it was not nearly so favored. Wood decays much faster than metal, so many of the American conservatories of the time are now gone.

Conservatories were surprisingly common in northern California in the nineteenth century. Wealthy citizens trying to keep up with the Joneses on the East Coast erected private greenhouses on their estates and created conservatory rooms in their urban mansions. Oakland had a considerable reputation in California for having the finest and most exotically stocked conservatories.

In fact, San Francisco's Conservatory of Flowers also owes its existence to one of these early American tycoons. James Lick, a wealthy businessman who made his fortune in real estate, ordered the greenhouse for his Santa Clara Valley estate. Unfortunately, Lick died before it was ever assembled, and the parts remained in their shipping crates, gathering dust. Put up for sale by his trustees, the components were purchased in 1877 by a group of twenty-seven civic-minded San Francisco businessmen and offered to the city to be built in Golden Gate Park. The gift was accepted by the Park Commission, who hired Lord & Burnham, a greenhouse manufacturing company from New York, to oversee construction.

Beyond these basic facts, though, the history becomes more confused. Conflicting sources state that the conservatory's pieces were created alternately in France, England, or Ireland, but no documentation exists to support any of these claims, and it remains unclear whether the components were shipped from Europe or manufactured in California. Significant use of old-growth redwood and other native trees in the building's infrastructure supports the theory that some sections of it were constructed on the West Coast. Some say a portion of the original materials went down with their ship in a storm. We may never know.

The conservatory was an instant sensation when it opened in 1879 and quickly became the most visited location in the park. The original configuration of the interior spaces included a fountain in the entryway and another in the Palm Room, under the dome. The east wing featured the Orchid House and an aquatic plant gallery with a large pond. In the west wing, the conservatory displayed flowering and ornamental foliage in one gallery and hardwooded plants, like azaleas, in the other.

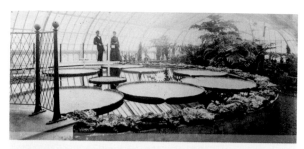

Giant Amazon water lilies have thrilled conservatory visitors since the 1880s. Courtesy of the San Francisco History Center, San Francisco Public Library.

The conservatory's collection at the time of the opening owed much to significant donations from the private collections of local businessmen.

Since opening, however, the Victorian gem has seen its share of trouble. In 1883, a boiler explosion ignited a fire that completely destroyed the dome. On this tragic day, the one and only resident parrot died in the conflagration, much to the distress of children throughout the city. Charles Crocker, the titan of industry responsible for much of the railroad system in the West, came to the building's rescue with ten thousand dollars for restoration.

It was at this time that the only major change in the overall form of the building took place. The original dome was slightly saucer-shaped. When it was reconstructed, it was given a more classical look, and two rows of windows were added at the base to raise the dome by six feet. The finial, or spire, atop the dome, once crowned with an eagle figure, now sported a more traditional turned wood ornament featuring the planet Saturn at the top.

The conservatory survived the great quake of 1906 intact. Thousands of homeless San Franciscans camped in Conservatory Valley and throughout Golden Gate Park in the days following that disaster. Unfortunately, tragedy caught up with the conservatory again in 1918, when the dome and an adjoining potting room burned.

Throughout the twentieth century, repairs were made to the building—some major, some minor, some good, some bad. A few decisions made along the way, such as the replacement of the lower venting windows with permanently closed concrete panels, and the use of more easily decayed woods (fir and pine) for structural repair, compromised the integrity of the building. When a devastating windstorm hit San Francisco in 1995, the fragile conservatory could not withstand the impact. The damage was severe.

The next day, newspaper headlines announced that the beloved conservatory was in peril, and in a rush of concern, hundreds of San Franciscans great and small spontaneously sent what they could to save the building, laying the groundwork for a historic restoration campaign.

Saving an American Treasure

The 1995 storm was one of the worst on record. Hundred-mile-per-hour winds tore through San Francisco, toppling countless trees, ripping off roofs, and leaving the conservatory in tatters. Forty percent of its glass panes lay smashed on the ground, several wood arches were damaged, and a portion of the collection of rare tropical plants was lost. Inspecting the building after the storm, Department of Public Works officials despaired to find that years of extreme moisture, both inside and outside the building, had rotted the infrastructure. It was clear that something had to be done to save this delicate, decaying glass palace.

But what? Little was known about the actual construction of the building. Not a single floor plan or construction drawing existed. Without any substantial documentation, the rehabilitation team was not even sure the parts could be disassembled. The decision was made to remove and reassemble an eight-hundred-square-foot test section of the west wing. Each component was painstakingly

Why Is It White?

Glass greenhouses were traditionally whitewashed to moderate the heat inside and the amount of sun that the plants received. Generally, a film of whitewash was applied in the spring to protect plants during the months when the sun is at its hottest. The whitewash would start to thin and become more transparent as it washed away with fall rains, allowing more light into the building as the days grew shorter and light intensity waned.

In a foggy city like San Francisco, the conservatory's plants would rarely if ever be in much danger of burning. But city officials felt strongly that the building should remain as historically accurate as possible, and so the whitewashing tradition continues to this day.

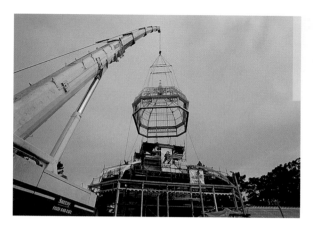

After a windstorm left the conservatory in tatters in 1995, $25 million was raised to restore the fragile building. Here, the dome is carefully lowered into place in January 2003. Photograph courtesy of Kevin J. Frest.

Because information on the building's origin was sketchy and there were no original drawings to consult, the conservatory was literally dissected, analyzed, and reassembled with a combination of new and old materials during its restoration. Photograph courtesy of Kevin J. Frest.

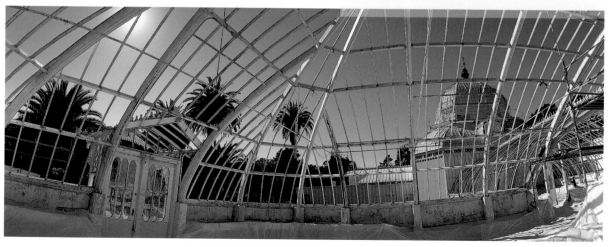

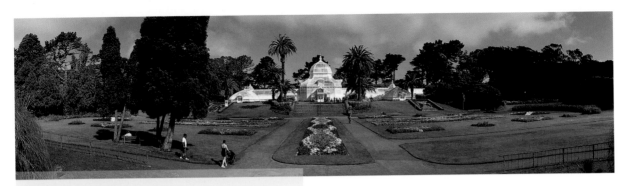

One of the most photographed landmarks in San Francisco, the Conservatory of Flowers is a gem of Victorian-era architecture.

separated to determine the assembly technique, and the various building materials were analyzed to determine their age, composition, and integrity.

This elaborate dissection was the basis for a five-year, $25-million rehabilitation process that got the attention of the World Monuments Fund. It placed the conservatory on its list of the one hundred most endangered monuments in the world, making it one of the only American buildings ever to be listed. The conservatory also became an official project of Save America's Treasures, an initiative of the National Trust for Historic Preservation.

Designated a city, state, and national historic landmark, the building is also recognized as a historic civil engineering landmark by the American Society of Civil Engineers, as it is an extremely rare example of a Victorian-era prefabricated building.

In September 2003 the conservatory reopened to the public, and it has since garnered numerous awards for excellence in historic preservation and for the exceptional horticultural displays within its five galleries: Lowland Tropics, Highland Tropics, Aquatic Plants, Potted Plants, and the ever changing Special Exhibits gallery, where visitors can learn something new every time, on subjects ranging from pollinators to medicinal plants to the reconstruction of the conservatory itself.

The Building

The Conservatory of Flowers is an intimate building measuring 12,000 square feet. Its arch-shaped wings extend from the central dome, for an overall length of only 250 feet. The building has a shallow E-shaped plan oriented on an east-west axis. Located behind the conservatory are several additional greenhouses for the maintenance and cultivation of the plant collections.

FINIAL
The ornamental spire bears the symbol of Saturn.

CLERESTORY
A row of windows added after the 1883 fire increased the height of the dome by 6 feet.

ARCH
The dominant form of the building. The 100 wooden structural arch pieces are laminated, comprised of three layers of wood.

DECORATIVE SCROLLWORK
Ornamental woodwork of the type favored in Victorian construction.

CHAMFERED CORNERS
Beveled corners are another primary design feature.

RAISED MASONRY FOUNDATION

WEST WING

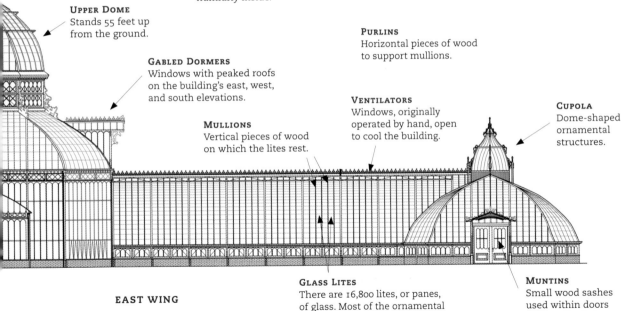

SCARF JOINTS
Interlocking, s-shaped joints connected with a wooden dowel were favored in arches, in order to reduce the use of metal connectors that might corrode from the humidity inside.

UPPER DOME
Stands 55 feet up from the ground.

GABLED DORMERS
Windows with peaked roofs on the building's east, west, and south elevations.

PURLINS
Horizontal pieces of wood to support mullions.

VENTILATORS
Windows, originally operated by hand, open to cool the building.

CUPOLA
Dome-shaped ornamental structures.

MULLIONS
Vertical pieces of wood on which the lites rest.

GLASS LITES
There are 16,800 lites, or panes, of glass. Most of the ornamental colored glass is original.

MUNTINS
Small wood sashes used within doors and small windows.

EAST WING

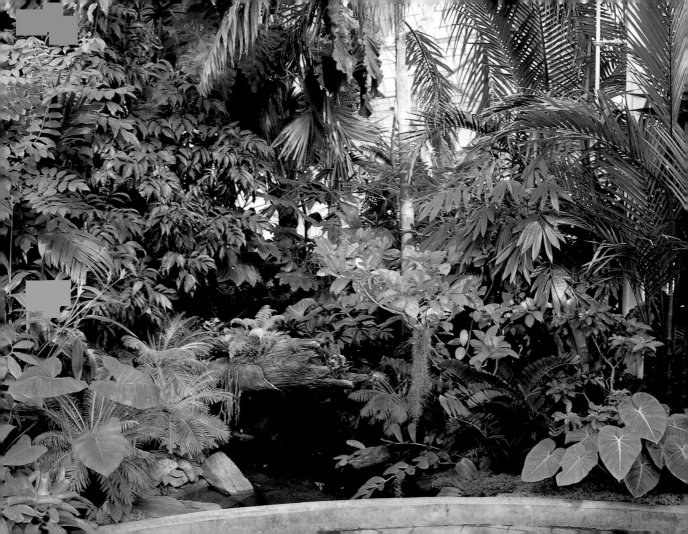

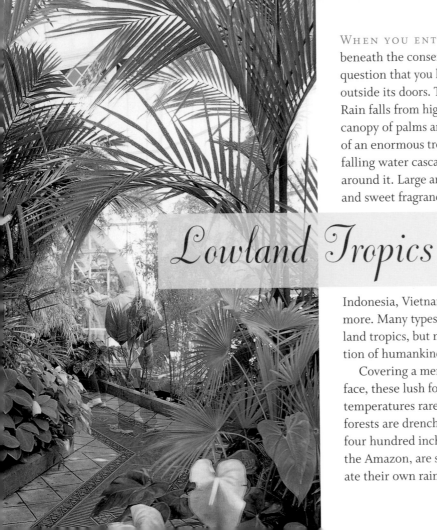

Lowland Tropics

WHEN YOU ENTER LOWLAND TROPICS, beneath the conservatory's dome, there is no question that you have left the cool, gray city outside its doors. The air is humid and warm. Rain falls from high above your head onto the canopy of palms and creeping vines. The stump of an enormous tree lies on the ground, while falling water cascades through the lush foliage around it. Large and colorful fruits hang heavily, and sweet fragrances mingle in the air.

Lowland Tropics is a steamy jungle of plants that are native to the low-lying tropical forests of countries such as Mexico, Brazil, Indonesia, Vietnam, Madagascar, Senegal, and more. Many types of forests occur in the lowland tropics, but none has stirred the imagination of humankind more than the rainforest.

Covering a mere 6 percent of the earth's surface, these lush forests hug the equator, where temperatures rarely dip below 70 degrees. Rainforests are drenched by at least eighty and up to four hundred inches of rain per year. Some, like the Amazon, are so wet and humid that they generate their own rain clouds. These forests support

an extraordinary diversity of species; over half of the world's plants and animals live in them.

For a plant, there are plenty of benefits to living in the rainforest. Foremost of these is year-round growth. The rainforest does not experience any significant temperature difference between summer, fall, winter, and spring, and the length of the day hardly changes either. With no seasonal cycle, no danger of frost, and consistently warm temperatures, many plants have no need to go dormant or otherwise protect themselves from climatic change; they can grow all year.

Jungle living, however, is no bowl of mangoes. The same things that make it such an ideal environment also make it very crowded and competitive. Thousands of plants vie for nutrients, light, and space to grow. To be successful here, different species have carved out very specific ecological niches for themselves.

The Forest from Top to Bottom

All forests grow in layers, but nowhere is this so pronounced as in the rainforest. Distinct populations of plants have developed ways to live in dramatically different microenvironments up and down the tangled branches of the forest's tallest trees. While this living system can look complex at first glance, it is generally possible to discern four separate zones—the emergent layer, the canopy, the understory, and the forest floor.

At the top of the rainforest is the emergent layer. Mushrooming crowns of trees that grow to staggering heights, sometimes more than two hundred feet, thrust up through the thick canopy at sporadic intervals, into the searing sunlight. These emergent trees are the clear winners in the rainforest race for light, but they must also endure extreme heat, low humidity, and strong winds.

Below this is the canopy layer—the most densely populated part of the rainforest. Here, an almost continuous layer of treetops standing anywhere from sixty to ninety feet above the ground supports 90 percent of the forest's flora and fauna; with lots of sunshine available, tree branches are packed with a whole host of hangers-on. A massive tangle of vines loops through the trees, and epiphytes—plants that grow on other plants—cling to every available inch of canopy real estate.

The understory is a different story altogether. Only 2 to 15 percent of the sunlight that reaches the canopy penetrates below to this layer, which is dark,

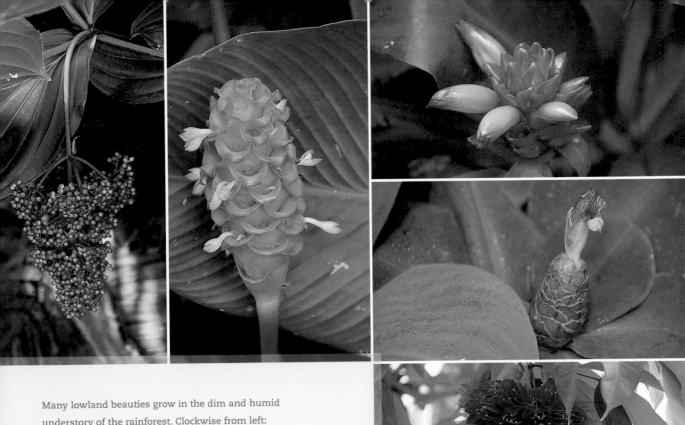

Many lowland beauties grow in the dim and humid understory of the rainforest. Clockwise from left: *Medinilla* sp., *Calathea burle-marxii* 'Green Ice,' *Costus curvibracteatus*, *Costus malortieanus* (spiral ginger), and *Brownea coccinea*.

still, humid, and surprisingly open. Young trees compete for the light here, along with leafy plants that can withstand low light. To ensure reproduction, many plants here have large, pale flowers so that pollinators can spot them easily. Growers of indoor plants will likely recognize some of these understory plants, since some species of ficus and many other common houseplants are denizens of this layer.

Very little grows on the forest floor. It receives less than 2 percent of the sunlight coming through the canopy, so only the plants most tolerant to low light, such as the prayer plant, can grow here. The main feature of the forest floor is the prominent tree roots that weave and snake through the shallow leaf litter.

Surviving and Thriving in the Jungle

This wild profusion of life up and down the forest layers attests to the incredibly resourceful nature of tropical plants. Competition for sunlight, space, and nutrients has resulted in a whole host of special adaptations.

LEAVES For most plants, light is life. It is the essential kick-start for photosynthesis, the process by which plants trap the energy of light to make their own food. The shapes and sizes of leaves on rainforest plants are therefore a study in contrast, varying tremendously depending on where a plant finds itself in the forest hierarchy. The tallest trees have constant access to the sun, so smaller leaves are just fine for collecting light. The small size also helps to slow down the rate of transpiration, or water evaporation. At this height, conditions are extremely drying, so emergent trees often have thick, waxy leaves that lock in moisture and nutrients.

Many plants in the lower layers of the forest, where less light penetrates and temperatures are cooler, develop larger, thinner leaves. Transpiration occurs more slowly here, and the added surface area of enormous leaves, a hallmark of the jungle, helps to collect what little sunlight there is. Some of these leaves are a dark blue-green color in order to pick up red-wavelength light not used by the lighter green leaves higher up.

Plants in rainforests are exposed to almost constant rain and moisture. Mosses, lichens, and other small epiphylls that live on other plants' leaves thrive in this wet environment. This can be dangerous to their hosts, since it interferes with their ability to absorb light. So, to keep leaves dry and to keep

Large leaves on tropical plants indicate that water is plentiful. The leaves of the conservatory's banana plants can reach up to ten feet in length.

epiphylls off, many rainforest plants have smooth or waxy leaves: slick surfaces are much harder to get a foothold on. This smoothness sometimes extends to the bark of tropical trees as well. Some plants have drooping or hanging leaves that help shed water quickly, while others take it one step further, directing water straight to the soil and to their own roots by channeling water off of pointed leaf tips, or "drip tips." Small hairs can also help keep leaf surfaces dry.

In areas of the tropics where hurricanes and high winds are a fact of life, large leaves can be a problem. Palms have adapted to withstand gales by bending easily, and many allow wind to pass right through their feathery leaves. The banana has one of the largest leaves in the world, but it grows in abundance in storm-prone areas. All of the veins on its leaves are arrayed along the strong central rib—not, as with so many plants, webbed throughout. If the wind tears or shreds its leaves,

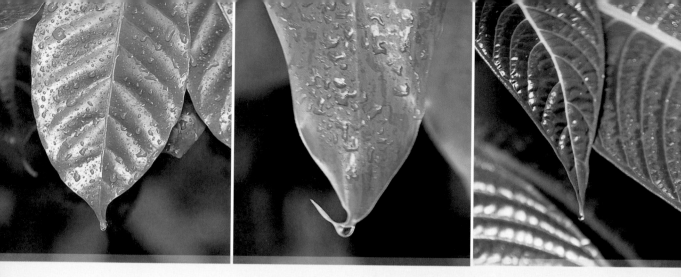

The constant rain and moisture in tropical rainforests encourage the growth of mosses and lichens, which can inhibit their host plants' ability to collect sunlight. Many plants have found ways to keep their leaves dry to combat this hazard. From left to right: the slick, waxy leaves of *Coffea arabica* repel water and make it hard for other plants to gain a foothold; the small hairs of *Costus curvibracteatus* condense water vapor into droplets that roll easily off the leaf; and the drooping leaves of *Hoffmannia ghiesbreghtii* have extended "drip tips" that channel water down to the plant's roots.

chances are the plant will survive, since the veins can continue to supply it with food and water.

The biological diversity of the tropical forest naturally extends to the animals that live there too, especially insects. With so many leaf-eating predators out

there, some plants have developed fascinating ways to look and taste unappetizing. Some leaves are shaped to look as if they have already been chewed on. The new leaf growth on many tropical plants is a reddish color, turning off potential diners

by signaling the presence of distasteful chemical compounds. These defensive chemicals can mean more than a bitter mouthful. Sometimes they are capable of interfering with the life cycle of the predator or even killing it on the spot. These potent repellants are the basis for a whole host of the medicines we use today.

Predators are discouraged from nibbling at the *Anthurium clavigerum* because the leaves look like they've already been chewed.

ROOTS In the rainforest there are, on average, only one to four inches of fertile topsoil. Because leaf litter decomposes so quickly in the heat and humidity, it never builds to any significant depth, and plants of the forest floor immediately take up those nutrients that do become available from this rapid decomposition. Add to that regular, heavy flooding, and the result is soggy, nutrition-deficient soil. And yet it supports trees that grow to incredible heights.

Specialized root systems are the key to many trees' success. A majority of the rainforest's towering trees form extensive mats of slender roots that stay very close to the soil surface. This helps

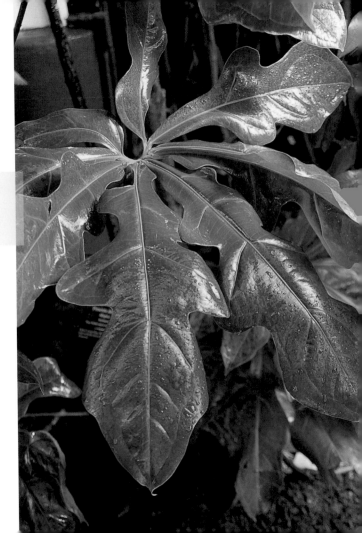

maximize the uptake of nutrients and provides structural stability as the roots weave together with other trees into one tightly meshed surface. Some trees have buttresses for added support. These are great vertical, ribbon-like flanges that radiate out around the base of the trunk. Still others have prop or stilt roots that, like a mass of pick-up sticks, stabilize the tree and have the added benefit of lifting it above the often-flooded forest floor.

Epiphytes—those plants, found high in the forest canopy, that live on the surfaces of other plants—are a dramatic example of plants with specialized roots. At these lofty heights, orchids, bromeliads, and many other epiphytes are ensured access to the sun, but the lack of soil means they must store their own water. Thick, waxy leaves help with this, and spongy aerial roots not only allow some tree-dwellers to cling to precarious surfaces, but to soak up moisture directly from the air, collect minerals from the dust and rotting leaves around them, and store all of this sustenance for a non-rainy day.

Working Geckos

The jungle just wouldn't be the same without insects. But here in the conservatory's urban tropics, some insects, like cockroaches, are just not welcome. The conservatory's solution to this ever-present metropolitan problem is geckos.

Geckos are small, hairy-footed lizards that come primarily from the tropics. These cute prowlers are known for their distinctive chirps and their voracious appetites. Their meal of choice is insects. Cockroaches, it turns out, are a meaty and succulent favorite.

Daytime visitors are not likely to spot these hardworking nocturnal hunters. The conservatory began releasing them, as well as anoles, a variety of lizard that changes color like a chameleon, into the exhibits in 1995 and continues to do this today as part of a progressive Integrated Pest Management (IPM) system. IPM is an environmentally friendly approach to pest control. When possible, pesticides are avoided in favor of monitoring and the release of predators. If a pest problem cannot be taken care of without a chemical product, only the least harmful substances are used.

Photo by Aukipa Hawaiian Images.

Aerial roots are not exclusive to epiphytes. Other plants in the rainforest, like the vining philodendron, rely on aerial roots to climb trees. The philodendron also sends out feeder roots—longer, thicker, and woodier—to retrieve water and nutrients from the soil.

Prop roots lift woody plants like the Seychelles stilt palm, *Verschaffeltia splendida*, off the often-flooded floor of the rainforest and help to stabilize them in the shallow soil.

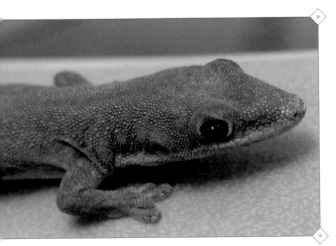

This imperial philodendron, *Philodendron speciosum,* is more than 100 years old—one of the oldest plants at the conservatory and the oldest of its kind in cultivation (photo taken prior to building rehabilitation).

VINES The philodendron is just one of the many creepers, vines, and lianas (woody vines) that thrive by climbing their way from the forest floor into the sun-drenched canopy. There are thousands of these species in the rainforest, some of which can reach lengths of three thousand feet. It is often hard to tell what is a vine and what is not. Some lianas get so thick that they are not discernable from trees.

Since vines do not need to support themselves, instead relying on their rigid neighbors, all of their energy goes into leaf production and rapid lengthening of their stems. These elongated stems send out clasping tendrils, spikes, roots, or some other climbing mechanism to grab hold of the

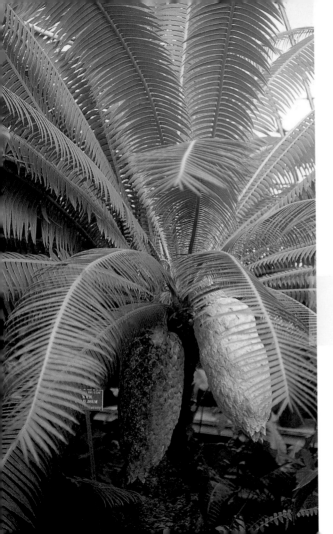

supporting tree. When lianas reach the canopy, they meander along branches from treetop to treetop. Strong but flexible, they serve as side-walks for tree-dwelling animals and insects. But they are also a problem. When a tree tangled in lianas falls, it can take many others down with it.

Jurassic Plants

Tropical rainforests are planet Earth's oldest living land-based ecosystems. Unlike the temperate forests to the north, which have been significantly altered by ice ages, the tropics have been left for

Primeval cycads like this *Dioon spinulosum* are some of the oldest plants still living on the planet. They first appear in the geological record more than 170 million years ago.

the most part untouched by climatic change. The fossil record shows that some of the forests of Southeast Asia have existed in pretty much the same state for 70 to 100 million years. Some individual species groups go back even farther.

Cycads first appear in the geological record about 170 to 180 million years ago. During the Jurassic

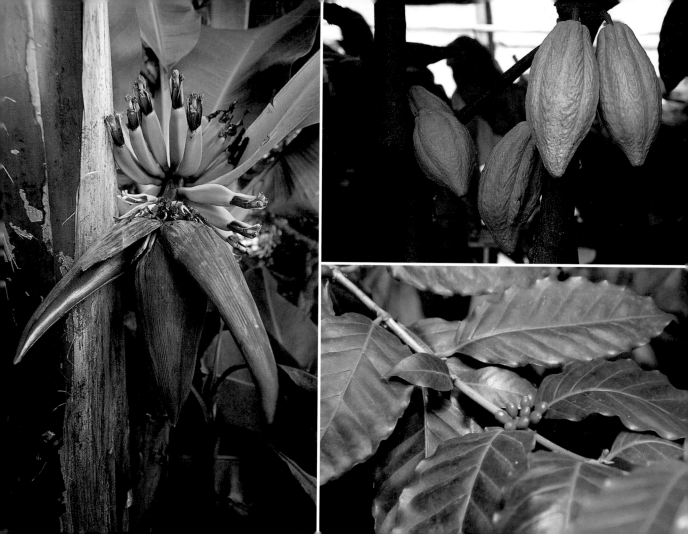

Period they literally covered the earth, and mighty dinosaurs walked among them. Amazingly, a few cycads still grow in the wild today; about one hundred and fifty species of these "living fossils" persist.

Cycads are primitive gymnosperms, or plants that bear their seeds "naked," not in a fruit but out in the open, in a cone. Though they resemble palms, they are related to pines and other conifers. Male plants release pollen that travels by wind or beetle to the females' cones.

The Tropical Cornucopia

From the cupboard to the closet, our lives are made more enjoyable thanks to the hundreds of everyday foods, medicines, and household items that come from tropical forests. Tropical crops are big business—some, like coffee, are among the most traded commodities in the world. Others, like timber bamboo, a renewable source of building material, may hold the key to sustainable living in the future.

People have been using and cultivating products from the jungle for centuries. The first known written record of banana cultivation in India goes back twenty-five hundred years, and cinnamon was once more valuable than gold. Over a thousand years ago, well before the arrival of Europeans, cacao plantations could be found across present-day Mexico. The cocoa they yielded was a popular drink in both the Mayan and Aztec empires. Montezuma was said to love it, drinking fifty goblets of the bitter brew each day.

When some of these tropical delicacies

Clockwise from far left: The banana is not actually a tree. What appears to be a trunk is a tightly compressed stalk of leaf stems. After it has produced a number of leaves, the plant sends up a purple, teardrop-shaped flower head. Next, white tubular flowers emerge and are quickly followed by green "fingers" that eventually become the familiar fruit. In some species, each stalk can produce up to 300 bananas. Pictured here: *Musa* sp. The seeds of cacao, *Theobroma cacao*, are the source of cocoa and chocolate. The flowers, and subsequently the seedpods, grow directly on the trunk and lower branches of the plant, a growth pattern known as cauliflory. Common in the tropics, cauliflory helps plants reproduce by providing mammals that ingest and disseminate seeds easy access to the fruit. Coffee, *Coffea arabica*, ranks just behind oil as the world's second most-traded legal commodity.

reached European shores, they caused an enormous sensation. The pineapple was so rare and prized in the 1600s that King Charles II of England posed for an official portrait with the fruit, to assert his royal privilege. Later, in colonial America, the pineapple was an essential component of stylish table settings, earning an enduring association with hospitality and welcome.

Palms

Throughout human history, people have been so dependent on palms for food, clothing, and shelter that the eighteenth-century botanist Linnaeus believed we should be referred to as "palmivorous." Linnaeus was the great classifier of plants, creating the system by which all plants have received their two-part Latin names. His respect for palms is evident in the name he gave their order—

Colorful palms are an eye-catching feature of the lowland tropics. Left to right: Sealing wax palm, *Cyrtostachys renda*; ivory cane palm, *Pinanga coronata*; areca palm, *Areca vestiaria*.

"Principes," the princes of the plant kingdom. The common name "palm" was inspired by the plants' leaves that fan out like fingers on a hand.

An ancient family of plants, palms appeared on Earth during the Upper Cretaceous Period, 65 million years ago. These days they can be found all over the world, but their greatest concentration is in the tropical lowlands and on islands. Southeast Asia has the greatest variety by far.

This family boasts a lot of botanical "biggests," including the plant kingdom's biggest seed (the massive *coco-de-mer* of the Seychelles, at more than fifty pounds), the largest leaf (*Raphia* spp. of Africa, at seventy-five feet long), and the largest flower stalk (*Corypha* spp. of India and Sri Lanka, at twenty-five feet tall, with up to sixty million flowers!).

People throughout the tropics rely on palms to make everything from soap to wine, doormats to entire houses. The six palms with the most economic value are the African oil palm, the coconut, the date, the carnauba and ouricury wax palms of Brazil, and the betel nut, chewed widely in Southeast Asia and India as a mild stimulant, breath sweetener, and appetite suppressant.

An Ecosystem in Peril

Rainforests are fragile and do not recover easily when they are disturbed. They are old, complex, and depend on the success of a very fine balancing act carried on by the thousands of species that live in niches within them. The niches are so specialized that, for example, an entire population may occupy just one tree, a situation with terrible consequences if the tree is burned or cut down. Other species require a number of contiguous acres in order to survive, a severe problem if parts of their area are cleared.

The nutrient cycle is equally delicate. Most of the nutrients in the rainforest are in the vegetation and the animals, not the soil. Overharvesting of plants or animals can disrupt the intricate ways in which these organisms recycle nutrients for each other. If the forest is cut down or burned, the nutrients in the shallow soil are quickly depleted, making it impossible for plants to grow there again. And since the soil is held together by tree roots, massive erosion can also result from clearing.

The rate of extinction in rainforests is staggering. Every day, 137 species disappear forever as an estimated two hundred acres of rainforest, a land mass the size of New York City, are cleared. At

this rate, scientists predict that almost all tropical rainforests, and the thousands of plants and animals that live there, will be gone by 2030.

A complex snarl of issues is at work here, including growing world populations with increasing needs for resources, wasteful consumption in wealthy nations, desperate poverty in tropical countries, and the financial temptation of large-scale corporate and government-funded development. Rainforests are harvested for timber and wood pulp and chips for paper production. They are also cleared to make way for cattle ranches, other livestock, and farming. Among the biggest threats to the rainforest today are mining and oil exploration and production.

The clearing of rainforests is having a dramatic impact on global climate change. Rainforests hold enormous amounts of carbon in their vegetation. When these plants are burned or cut, they release carbon into the atmosphere. This is the second largest factor contributing to the greenhouse effect and global warming, a legacy of overconsumption we will all have to grapple with in the future.

As this sign points out, the lowland tropics are home to more kinds of trees than anywhere else on earth.

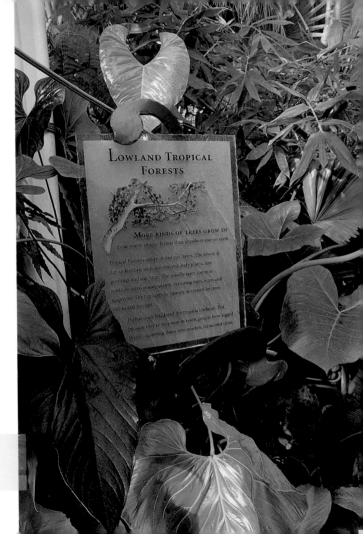

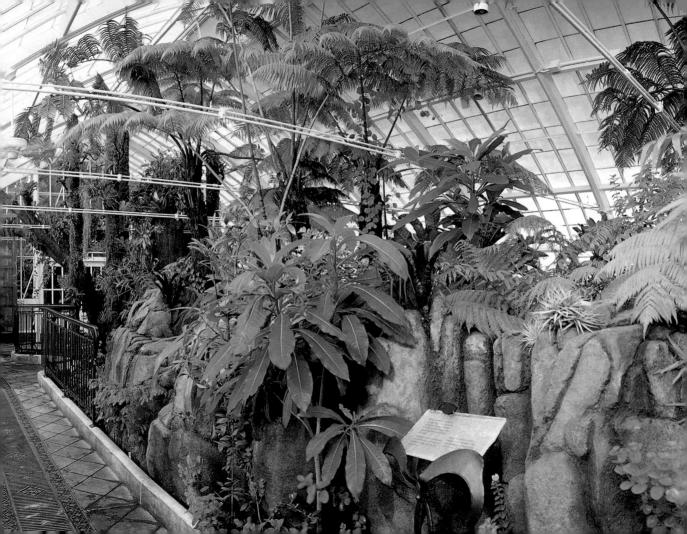

THE CONSERVATORY'S HIGHLAND TROPICS gallery may be just next door, but it is a world away from the low-lying rainforest. Here, temperatures are refreshingly cool, and colorful orchids grow on moss-covered trees. This gallery provides an intimate glimpse of the life in the mountain forests of the tropics and is home to one of only four public collections in the United States of highland tropical plants.

Several kinds of highland forest occur in the tropics—lower montane forest, cloud forest, upper montane forest, and sometimes even alpine forest, when mountains are tall enough. Of all of these high-elevation jungles, however, the cloud forest casts the greatest spell on the imagination.

Cloud forests are eerie and wonderful places. Frequently shrouded in mist and fog, and cascading with waterfalls, their steep hillsides are covered by short trees, twisted and gnarled by

Highland Tropics

The highland tropics are distinguished by a multitude of epiphytes—plants that grow on other plants. Orchids, bromeliads, mosses, and many other plants that collect moisture directly from the air do particularly well in the highlands, where nearly constant mist and clouds are reliable sources of water.

The enormous leaf of *Gunnera insignis* can be as large as six feet wide. Its size is an indication of the abundant supply of water in the cloud forests where it grows. Its umbrella shape draws water into its center where it can then drip down to the roots, and the leaf can also shed moisture from its tips.

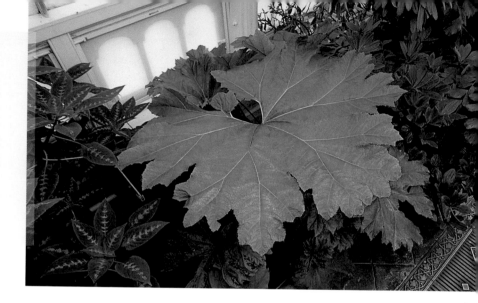

the harsh elements and the weight of the thousands of plants that live on their limbs.

The majority of cloud forests are found in southern Mexico, Central America, and South America. Others exist in Southeast Asia, New Guinea, tropical Africa, Madagascar, and some of the islands in the South Pacific. They occur in the high mountains, usually at elevations of five thousand to ten thousand feet. On steep and humid equatorial islands, they can begin as low as sixteen hundred feet.

Like the rainforest, tropical cloud forests are wet. Cool though they may be, they experience nearly 100 percent humidity throughout the year. They receive up to two hundred inches of rain annually, and when it isn't raining, there are always the clouds. Trees and plants in this forest are adept at capturing water from fog and mist, storing it, and slowly dripping it down to the ground. Cloud forest soil is like an enormous sponge, a mass of damp humus and peat that, like a natural water

tap, slowly releases a steady supply of fresh, filtered water to animals, plants, and people downstream.

With the plentiful supply of water, the cloud forest's biodiversity is spectacular and rivals that of the rainforest. Thousands of species of plants and animals live here, most still unknown to science. Many of these are endemic—they can be found nowhere else. This specialization sometimes becomes so pronounced that species can vary dramatically from mountaintop to mountaintop.

Living It Up

The lowland tropics are host to a whole variety of epiphytes, but nowhere are they so absolutely the kings of the jungle as in the highland mountains. Mosses, orchids, bromeliads, and ferns are some of the plants that cling to the forest canopy, living on the surfaces of trees and other plants. In the cloud forest, epiphytes make up roughly half of the total biomass.

When so much water can be harvested from the air, it is no wonder that epiphytes thrive here, being well adapted, with specialized roots and leaves, to collect water and nutrients from their surroundings and store them away for a dry day. This is critical because, wet as this environment might be, epiphytes live without the benefit of soil in a virtual Sahara. Every drop of moisture and every trace of minerals count.

Epiphytes hang on to their precious leaves, rarely dropping them, as there is no way to get back any nutrients from them once they fall to the ground. To cut down on moisture loss, many epiphytes also have a specialized form of photosynthesis called CAM photosynthesis. All plants require carbon dioxide for photosynthesis. Most collect it during the day, when the sun is shining and they are actively photosynthesizing. They open the pores in their leaves to do this, but that allows water to escape. Epiphytes can't afford the risk. So they open their pores in the cool of the night and convert carbon dioxide into an acid they can use later, in the light. The other benefit of this system is that most other plants release carbon dioxide at night, making the supply plentiful.

Epiphytes are very good at this kind of give-and-take. After all, their lives depend on it. Epiphytes cling tightly to their plant supports but do not penetrate and pilfer nutrients from them. When they die, they decompose and create "suspended humus," an organic sponge that can be deeper and richer than the soil on the ground. On very old trees it can reach

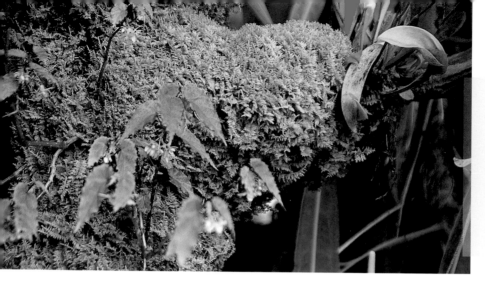

Suspended humus is an organic spongy layer of decomposing leaf litter and animal matter that can be as much as a foot deep on tropical tree limbs. The humus provides much-needed moisture and nutrients to the epiphytes perched high in the trees.

depths of a foot or more. Suspended humus is a gold mine for a huge number of insects, worms, and other animals, other epiphytes, and even the host tree itself. Some trees send out special roots to take advantage of the moisture and nutrients in the suspended humus that builds up on their own branches.

So, epiphytes are not parasitic, but they can be a heavy load. It is not unusual for a tree in the cloud forest to be loaded up with three hundred pounds or more of various epiphytes—not necessarily the best arrangement for the tree. Epiphytes cover up

sunlight-absorbing surface area, and they can shade lower branches. They soak up a lot of the water and nutrients that fall through the canopy on the way to the ground and to the roots of the trees. The weight makes the tree expend energy to reinforce its limbs. Sometimes it is just all too much, and a branch and all of its epiphytes fall to the forest floor. This breakage is one of the reasons trees in the cloud forest have such a gnarled appearance.

Epiphytes come in all shapes and sizes. Bryophytes like mosses and liverworts are the

smallest of the group. These grow so thick in the cloud forest that the landscape almost has a furry or fuzzy appearance. Like a soggy welcome mat, they sprout first and become the foundation that allows other epiphytes to take root.

Several kinds of epiphytic ferns also share life in the trees. The roots of aerial ferns grow like sponges, allowing them to trap and store water and nutrients. Organic debris is full of nutrients, so the staghorn fern's basket-shaped form allows it to catch as much as possible. When a leaf of the bird's nest fern dies, it curls back in toward the plant, rolling up any debris along the way and delivering it right to its sponge.

The beautiful bromeliad family ranges from the most famous of its members, the pineapple, to the most unexpected, Spanish moss (neither Spanish nor a moss), and it includes many epiphytes. Some

Often referred to as "air plants," tillandsias can take food and water through tiny silver scales on their leaves; they use their reduced root systems for attachment, not nutrient gathering. They can grow where most other plants cannot and have even been found growing on power lines. Pictured here: *Tillandsia fuchsii.*

bromeliads are terrestrial, growing in the ground. Others are lithophytes, which means they grow on rocks. But the epiphytic members of the family, which can even be found growing on telephone lines, have earned them the name "air plants." Most bromeliads are recognizable for their fantastic, tightly wrapped spirals of waxy leaves.

Orchids: A Bag of Reproductive Tricks

Orchids, undisputedly the reigning family of the epiphytic world, have driven many a collector mad with desire. When British horticulturists first brought these spectacular plants to Europe in the early nineteenth century, flower aficionados became so obsessed that a new term was

One out of every ten flowering plants on Earth is an orchid. They are found throughout the tropics, but the diversity of species and the sheer number of plants increases dramatically at elevations of one thousand to three thousand feet. The flowers of cool-growing orchids are often small and delicate, an adaptation to the harsher environment of the highland tropics. Orchid photographs here and on the following pages are by Ron Parsons.

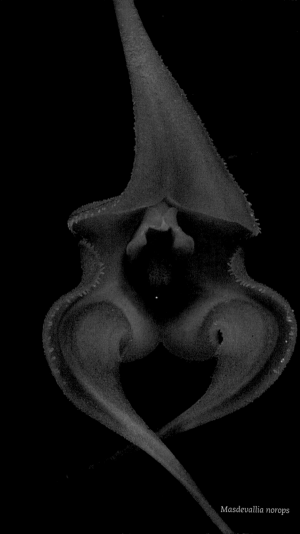

Masdevallia norops

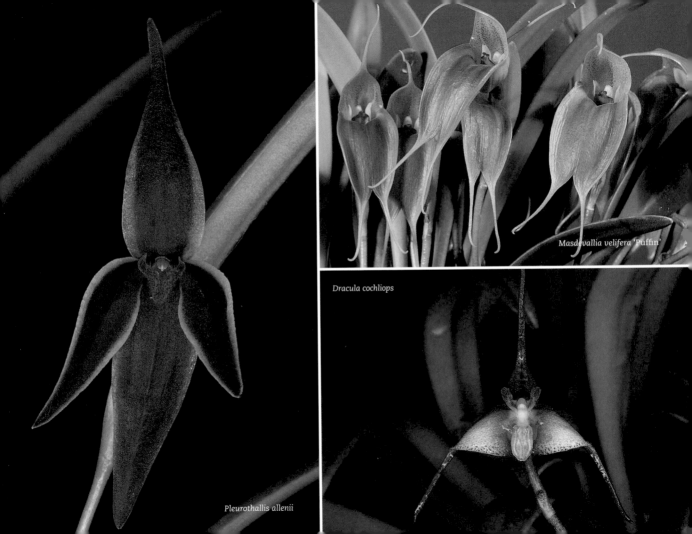

Masdevallia velifera 'Puffin'

Dracula cochliops

Pleurothallis allenii

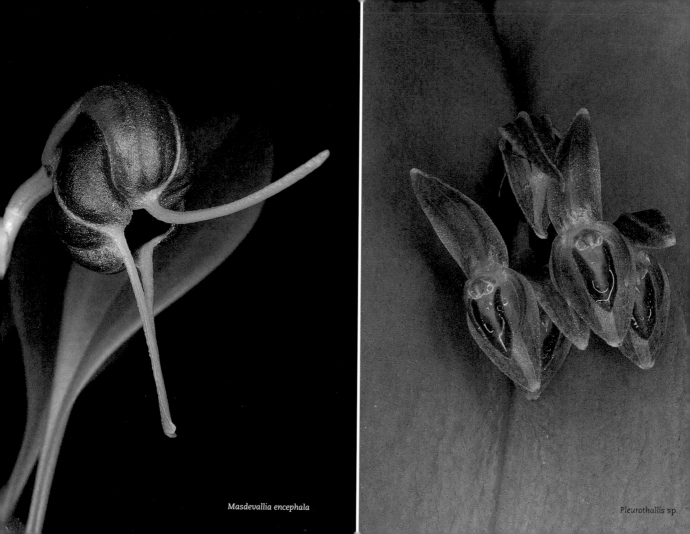

Masdevallia encephala

Pleurothallis sp.

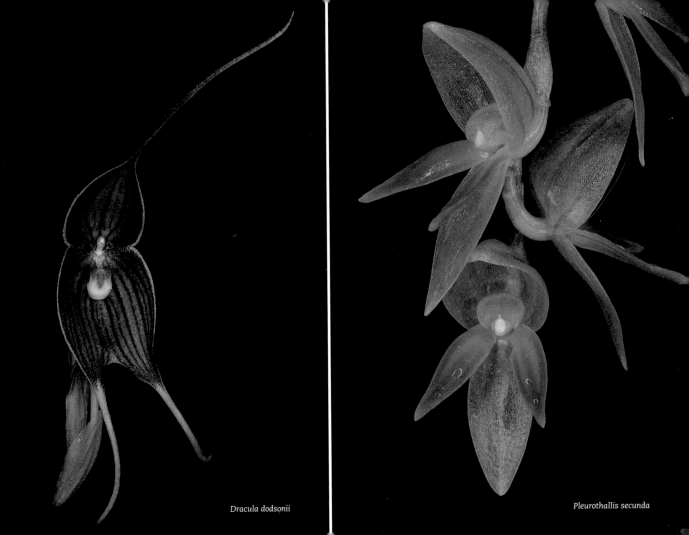

Dracula dodsonii

Pleurothallis secunda

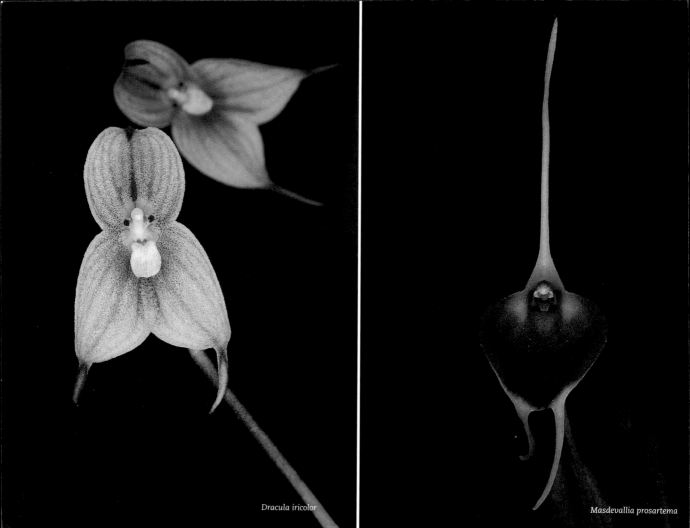

Dracula iricolor

Masdevallia prosartema

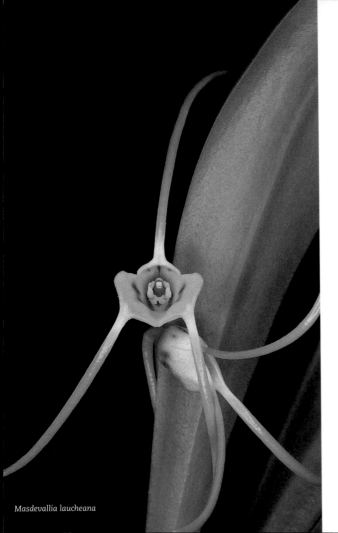

Masdevallia laucheana

coined to describe their passion, "orchidelirium." Growers today remain just as fascinated.

There is good reason for this orchid fever. The variety and range of these plants is unmatched. With an estimated twenty-five thousand species, orchids are one of the largest and most diverse families of flowering plants; one out of every ten flowering plants is an orchid. Many of these are narrowly endemic, occupying a single canyon or hillside or some other limited area.

Over 70 percent of all orchids are epiphytes. These tree huggers grow in many regions, but they are particularly abundant in the cloud forest. With thick, fleshy roots that absorb water and nutrients from the mists, they are well adapted to life there. These roots are covered in a layer of dead tissue called velamen that acts like a blotter, quickly sucking up moisture but serving as a protective barrier when dry.

But orchids are successful as a family for more reasons than their roots. They are also masters in nature's bedroom, so to speak. Their blooms are gorgeous, and that is no mistake. Plants must exchange pollen in order to form seeds, and flowers are actually intricate reproductive structures designed to get the attention of the insects they rely on for help

with this process. Many orchids have developed highly specialized means of luring pollinators.

One of the highlands' most strangely beautiful orchids is the *Stanhopea*. Some of the orchids in this genus have huge flowers, up to six inches long. These hang almost a foot below the plant on a pendulous stalk, looking like large flying insects. The flower's scent is strong and spicy and irresistible to male euglossine bees. When they land to take a drink of nectar, they slip on the slick surface and tumble down a chute. The only way out is through a series of internal paths which lead the bee right to the spot where the flower can tag its back with pollen. Once the bee is loaded, the flower releases him and off he flies, only to be drawn in by the next deliciously scented *Stanhopea*. As he makes his tight crawl through this second flower, the pollen from the first flower will be scraped off of him.

Orchids in other parts of the world also play these kinds of tricks on insects. Plants in the

A male euglossine bee that stops to sip nectar from a *Stanhopea* is likely to slip into the flower. To get out, he must crawl through a passage so narrow that any pollen he's carrying on his back will be scraped off, and before he leaves, he'll acquire more.

The Draculas

The Conservatory of Flowers is home to a renowned collection of Pleurothallid orchids. Its inventory is quite possibly the largest public collection in the world. Of particular note are the conservatory's *Dracula* orchids. And while there is one species called *Dracula vampira* 'Bella Lugosi,' these orchids did not get their name from the classic Hollywood monster, but from the Greek word for "little dragon," due to the flower's face-like markings and unusual hinged lip. Over one hundred *Dracula* species are found in Central and South America, half in the highlands of Ecuador alone.

genus *Ophrys* are particularly effective at fooling male wasps and flies by mimicking exactly the fragrance and appearance of a female insect. When a male attempts to mate with the flower, clumps of pollen stick to his body. The confused male moves on without so much as a complimentary drink of nectar. But soon he spies another "potential mate" and moves in to try again, depositing the first plant's pollen onto the other.

This mimicry isn't all fun and games. Some *Oncidium* species exploit the territorial nature of bees by dangling flowers that look like antagonists in front of them. When a breeze kicks up and the flowers begin to move around on their long stalks, the bee attacks, butting the offending flower like a bull. With a forehead full of pollen, the bee flies off, only to get drawn into another floral battle.

Not all orchids smell like a divine perfume—not to us at least. But a number of orchids in the *Paphiopedilum* genus have a scent like rotting fruit or meat that flies find delectable. On top of the aroma, this orchid's brown, purple, and green petals are dotted with black warts that trick a fly into thinking there are several other flies at the feast already. As with the *Stanhopea*, a slippery surface sends the fly sliding inside and then crawling out of pollen-laden tunnels.

The *Catasetum* orchid dispenses with all that fuss and just blasts bees with pollen. When bumped, this trigger-happy orchid ejects pollen onto the insect's body, where it sticks, riding to the next flower.

Once pollinated, a single orchid can produce millions of tiny seeds so small they are measured in microns. These ultra-light seeds are equipped with a variety of flying mechanisms so that the wind can carry them to the far reaches of the canopy.

Vanishing in the Mist

So much is still unknown about cloud forests, but they and the thousands of orchids and epiphytes that live in them are in grave danger of disappearing entirely in as little as ten years' time. The same pressures that are destroying rainforests are affecting the world's cloud forests—logging for timber and fuel, clearing to make way for cattle grazing and coca plantations, and paving for transportation and telecommunications networks. Ecotourism is a mixed blessing, bringing hotels, access roads, and agriculture into pristine areas. These forests are also particularly sensitive to global warming, due to the specialized, cool tropical conditions they need to thrive. Increasing temperatures cause cloud lines to move farther up mountains, leaving the forest below to dry out. In Monteverde, Costa Rica, where the cloud forest only exists in a narrow band of three to four hundred meters above sea level, an upward

movement of the cloud line of even fifty meters would have a huge impact. Scientists are already noting bird and bat species relocating to higher elevations, and some amphibians have disappeared altogether.

This is not just bad news for the forests, but also for the millions of people who receive water from these natural storage tanks. Cloud forests play an extremely important role in the hydrology of tropical watersheds. Their ability to capture, hold, and filter water results in billions of gallons of fresh drinking water for communities throughout the tropics. Forty percent of the water consumed by the 850,000 residents of Tegucigalpa, Honduras, comes from the cloud forests of La Tigra National Park. Forests in the Udzungwa Mountains of Tanzania provide enough water to power the hydroelectric dams that keep the massive city of Dar es Salaam going.

Hawai'ian Tree Ferns

Walking under the lacy fronds of giant tree ferns just might be the quickest way to be transported back to the time of the dinosaurs, which is when these plants proliferated. Tree ferns differ from their smaller cousins in that the rhizome—the

Tree ferns like this *Cibotium glaucum* proliferated during the time of the dinosaurs.

underground horizontal stem that all ferns share—happens to be above ground, long, and very strong.

In Hawai'i there are over eight hundred species of tree fern, and Hawai'ian people through the ages have depended on them for everything from food to surgery. The silky brown threads that cover the unfurling fiddleheads, called *pulu* on the islands, were used in an embalming process and also as a surgical dressing. During times of famine, Hawai'ians would eat the starchy core of the trunk. Unfortu-nately, many species are threatened as the tree trunks are used more and more widely by the nursery industry as decorative potting media.

Vireya Rhododendrons

Vireya Rhododendrons account for approxi-mately one third of all *Rhododendron* species. Native to Southeast Asia, these lovely flower-ing plants are found at all elevations, but most

grow in the cool mountains. Many of the over three hundered species are epiphytes.

The vireya rhododendron was introduced to England in 1845 and soon became enormously popular with Victorian collectors, who considered a garden full of rhododendrons the height of fashion and an important measure of one's social respectability. The famous Veitch Nursery in England went to work creating unique hybrids, producing entirely original plants by impregnating one species' flower with the pollen from another. It is believed that over five hundred hybrids were created by the end of the

The Making of the Conservatory's Cloud Forest

Oak, alder, and other cloud forest trees take a long time to grow from seedlings, and mature trees don't easily fit through doorways. When the Conservatory of Flowers created its beautiful Highland Tropics exhibit in 2003, staff faced a challenging issue—how to create an ancient forest without actual trees.

Most visitors are surprised to learn that the moss-covered trees in the Highland Tropics gallery are man-made. With their thick moss cover and twisted branches, they look like living trees, but they are not.

At the core of each tree is a galvanized metal pipe. These pipes were wrapped with long-fibered New Zealand sphagnum moss and

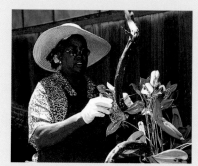

Volunteer Caryle Wyatt assembles one of the fabricated tree branches that serve as the foundation for the conservatory's display of renowned cool-growing orchids.

then wrapped again with stainless steel chicken wire to hold this first layer in place. A final wrap of green sheet moss was then attached to the wire covering, putting the finishing touches on the trees' naturalistic and furry suspended humus layer.

The branches on these trees are California manzanita, a gnarled local wood that seemed like a good fit for the cloud forest look. The big surprise here is that these branches are detachable so that the orchids and epiphytes growing on them can be cared for in the support greenhouses.

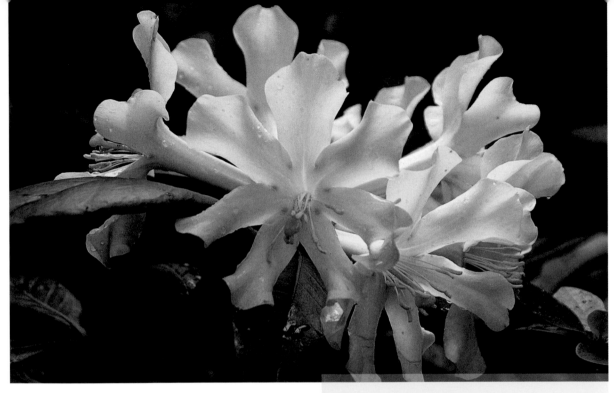

Rhododendrons are a familiar site in many parts of the world, but vireya rhododendrons are native only to Southeast Asia.

nineteenth century. Almost all of these were lost to horticulture during World War I when many former gardeners, consumed by world events, neglected their collections and conserved fuel by ceasing to heat their greenhouses.

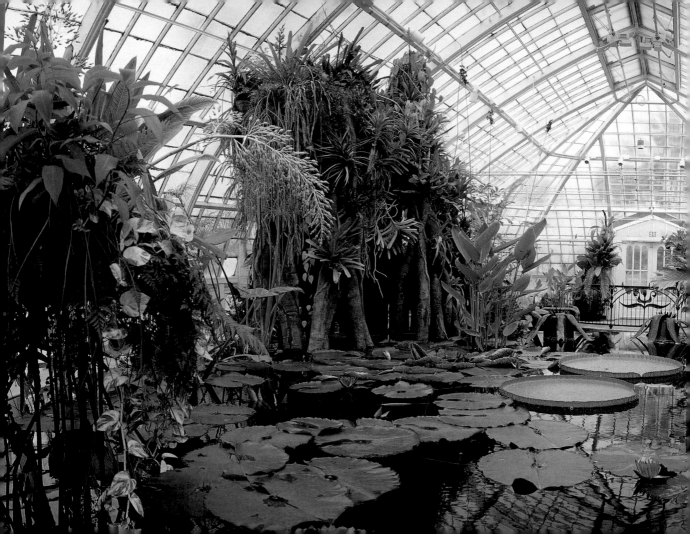

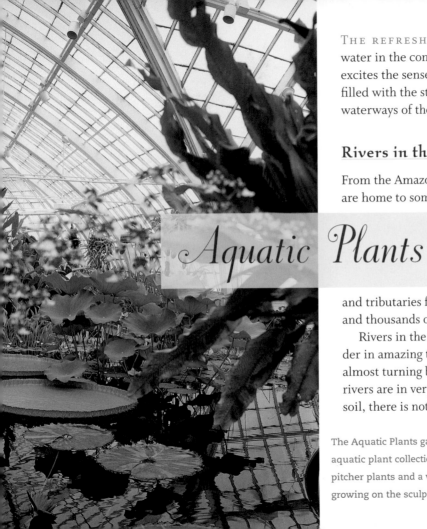

THE REFRESHING SOUND OF SPLASHING water in the conservatory's Aquatic Plants gallery excites the senses. Beautiful cascading pools are filled with the striking plants that crowd the waterways of the tropics.

Rivers in the Rainforest

From the Amazon to the Mekong, the tropics are home to some of the world's largest and most legendary rivers. The precipitation that makes rainforests so special also makes for some tremendous watersheds. Countless streams, creeks, and tributaries feed into mighty rivers thousands and thousands of miles long.

Rivers in the tropical lowlands fork and meander in amazing twists and turns, sometimes almost turning back on themselves. Since these rivers are in very flat areas with a soft, clay-like soil, there is not much to predetermine their

The Aquatic Plants gallery features not only the conservatory's aquatic plant collection, but an extensive collection of carnivorous pitcher plants and a whole host of bromeliads, many of which are growing on the sculptural base of the infamous strangler fig.

Aquatic Plants

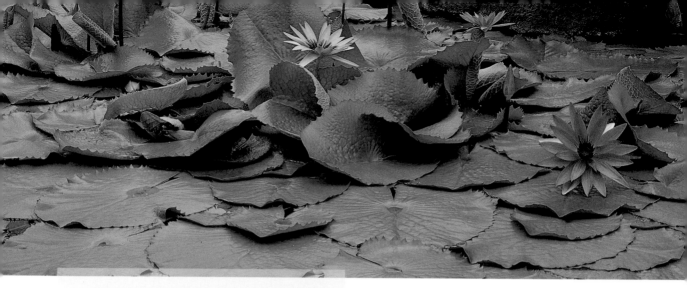

The waterways of the tropics are crowded with aquatic plants like water lilies (*Nymphaea* spp.), vying for light and space in which to grow. Floating plants sometimes grow so dense that trees, grasses, other aquatic plants, and even animals can live on them.

course, and they snake lazily along as they wish, changing direction frequently and leaving large lakes and swamps where they once flowed.

The sheer volume of water keeps things pumping, however. Mind-boggling amounts of water flood vast areas of forest and carve great river cliffs as much as one hundred feet high. The Amazon is the most voluminous river on earth. One-fifth of the world's river water flows from its mouth.

Most rainforest rivers are, like the Amazon, a muddy brown. Heavy rains constantly send sediment into waterways—a billion tons of it a year, in fact. Torrential downpours can turn a dry creek bed into a raging river in a matter of hours, taking soil, plants, trees, and even an occasional house with it. Black-water rivers are common in the

tropics as well. Like deep, clear black tea, these rivers get their color from the dissolved vegetation they contain.

Aquatic plants grow in abundance in rainforest waterways, thriving in the sunlight that shines through these breaks in the forest canopy. Floating meadows are a common sight. Great patches of floating plants can grow so dense that a whole community of small trees, shrubs, grasses, other plants, and even animals can thrive aboard these living rafts. Some reach up to a square mile in area.

Victoria amazonica:
A Giant among Water Lilies

Floating aquatic plants are one of the great spectacles of the tropical watershed, and none is so renowned as *Victoria amazonica*, the great Amazon water lily. The size of its gargantuan leaves and its tray-like appearance led both the indigenous Guarani and later European collectors to refer to this plant as a giant water platter.

Amazon water lilies are native to the calm, shallow waters of the Upper Amazon River Basin and also grow in lakes and flooded grasslands. Like so many other rainforest plants that must compete for

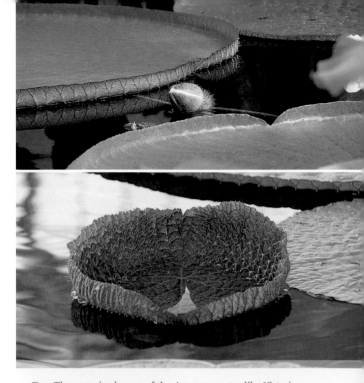

Top: The massive leaves of the Amazon water lily, *Victoria amazonica*, can grow up to eight feet across. These platter-like pads with upturned edges are notched in two places so that water does not puddle on their surfaces. Bottom: The leaves of the Amazon water lily make their way to the surface curled up in tight balls that then unfurl.

sun, Amazon water lilies have oversized leaves—the enormous pads measure four to eight feet in diameter and are said to be able to support the weight of a child. The leaves emerge curled up in tight balls and then unfurl on the water's surface. The Amazon is full of manatees and other hungry aquatic vegetarians, so a mean set of spines on the underside of the leaf discourages snacking. Floating perfectly flush with the water's surface in order to expose every possible square inch to sunlight, the leaves have a system of strong, hollow veins arranged in an intricate geometric pattern that helps to stiffen them. Their short stalks pipe oxygen down to the submerged roots. A characteristic upturned edge, a sort of bumper, aids in the fight for space on the crowded surface of the water. To keep from sinking during heavy rains, the leaves are notched in two places, allowing water to drain off their surface.

Timing is everything for the pollination of *Victoria amazonica:* the flowers bloom for only two days, and they depend on just a few species of scarab beetle for pollination. When the flower opens in the evening, it heats up and begins to emit a strong pineapple scent. The scarab beetle zooms in to feast on nectar and to get cozy in the warm folds of the petals. As the night wears on, the flower closes around the

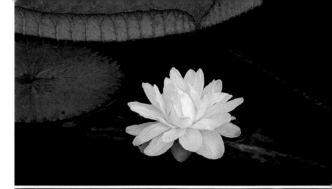

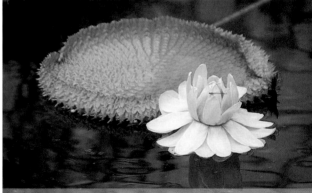

Top: When the bloom of *Victoria amazonica* first opens, it is creamy white and very fragrant, which attracts the scarab beetles that it depends on for pollination. Bottom: Later the bloom turns a beautiful rosy pink. The bloom lasts for only two days.

distracted beetle, trapping it inside. The next day, when the flower has matured, it dusts the happy captive with pollen. By that evening, the flower has turned a beautiful pink color and then reopens, releasing the pollen-covered beetle. The first time an Amazon water lily bloomed in front of the public anywhere in North America was in the 1880s, at this very conservatory, forever earning this behemoth of the water plants a special place in local history.

Art in the Conservatory

Many master craftspeople and artisans were involved in recreating the conservatory's exhibits in 2003. Visitors will notice their artistic touches throughout the building, from the lovely glass and metal interpretive signs to the wooden orchid cases to the stonework on the pools. Perhaps most noticeable is the glass and metal *Victoria amazonica* that hangs from the ceiling in Aquatic Plants.

The conservatory was looking for an innovative way to allow visitors to see the intricate architecture on the underside of the lily's gigantic leaves. See-through panels were installed for the pools, but this still did not reveal the truly awe-inspiring pattern of the veins. Then the idea of a great, suspended leaf pad emerged, and the conservatory commissioned a glass artist to realize the design.

Beautiful white and pink glass blooms also help visitors to understand the plant's pollination cycle.

The conservatory's glass and metal lily provides a view of the underside of the Amazon water lily leaf, where sharp thorns deter aquatic leaf eaters.

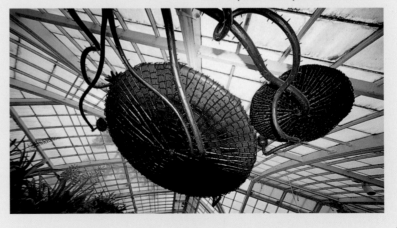

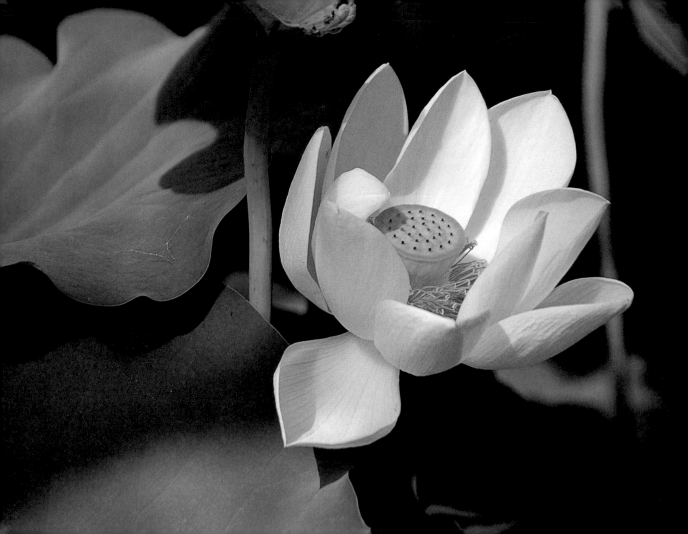

Lotus: The Sacred Bloom

Another aquatic plant that is sure to catch the eye is the sacred lotus, whose pale pink bloom is intimately linked with Buddhism, symbolizing perpetual life, purity, and beauty. Buddhist art is replete with images of the lotus. The lotus is also the national flower of India, figuring prominently in spiritual lore. Hindus believe that Brahma, creator of the universe, sprang from a lotus blossom.

It is no wonder that so many cultures throughout the lotus's native Asia hold this plant in such high esteem. It is both breathtaking and useful. In China and Taiwan, the starchy rhizomes—underground stems—are a dietary staple. All parts of this plant are used medicinally as well.

Emerging from the Waters

Floating plants like the water lilies are aquatic, but there are other types of aquatic plants as well. "Emergent" plants have submerged roots, but their leaves extend above the water. Examples of emergents at the conservatory include two plants that have shaped human history: rice and papyrus.

Rice is the principal food of at least half the

People throughout Asia treasure the sacred lotus, *Nelumbo nucifera*, for its symbolic and spiritual value as well as for its usefulness. All parts of the plant are edible and many are used medicinally, particularly the seeds.

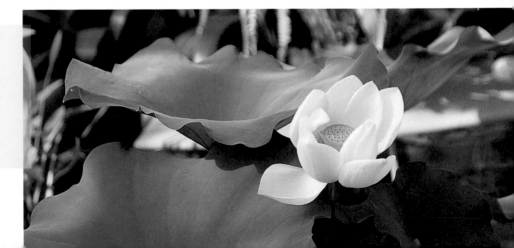

world's population. This tall grass has fed more people over a longer period of time than any other crop. In classical Chinese, the same term is used for

Rice, *Oryza sativa*, feeds 50 percent of the world's population today.

both "rice" and "agriculture." There are two main groupings of rice: upland rice and wet rice. Wet rice, the most economically important, is the rice typically cultivated in paddies that must be flooded for two to three months during its growth cycle.

Papyrus, a native of northern and tropical Africa, is believed to have been used for food, medicine, fiber, and shelter for more than four thousand years. Most famously, this sedge is the material that ancient Egyptians used to make paper, layering and pressing strips of leaves into sheets. Paper became so valuable as an export that the pharaohs made its production a state monopoly and guarded their secret method closely. There was no real competition to papyrus until A.D. 105, when Ts'ai Lun, a Chinese court official, invented paper more or less as we know it today—as a mat of separated fibers.

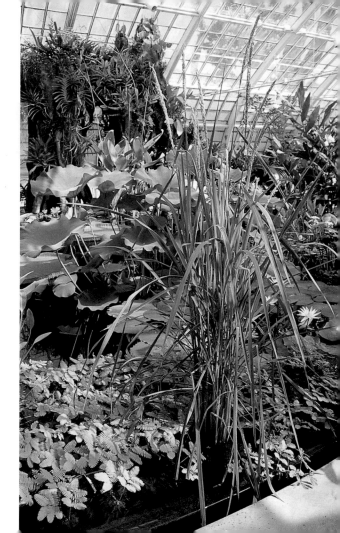

61

Bromeliads

Bromeliads can be found growing on tree limbs throughout the conservatory, but although they are not aquatic, it is in the Aquatic Plants gallery that the full range of these riotous beauties, with their brilliantly colored blooms and fantastic foliage, can be appreciated.

Except for one species that grows in Africa, bromeliads grow exclusively in the Americas, with the greatest number found in Brazil. Some grow in the ground, but most grow on rocks or as epiphytes, high in the trees without access to moisture in the soil, and for that reason they have developed a unique ability to hold and store water.

All bromeliads have spiraling leaf arrangements, but many species have such tightly overlapping leaves that the center of the plant acts as a little water reservoir. Often referred to as "tank plants," some of the biggest can contain up to twelve gallons of water.

It's not just the plants that benefit from these little pools. In their native habitats, bromeliads function as a sort of spa for creatures who depend on them to provide moisture in dry weather. From insects to frogs and even crabs, scientists have counted up to two hundred and fifty species living inside these plants, some for entire life cycles. Bromeliads reap the rewards of all this activity. As the tenants die, they add to the rich nutrient stew of leaf litter, insects, animals, and feces that collects in the water-filled cups.

Bromeliads are often referred to as tank plants, since their spiraling leaf arrangement sometimes overlaps so tightly that water collects in the reservoir. Clockwise from top left: *Aechmea fasciata*, *Vriesea ospinae*, *Tillandsia leiboldiana*, and *Neoregelia* hybrids.

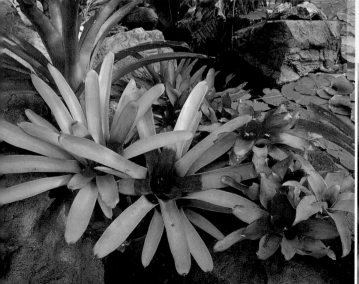

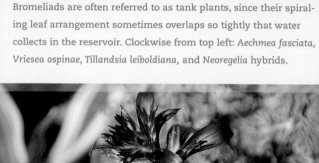

Fatal Attractions

Not all relationships in the tropical forest are so cozy. Some are downright deadly. Aquatic Plants features two examples of such dangerous liaisons: the strangler fig and the carnivorous *Nepenthes*.

THE STRANGLER FIG Standing on the edge of the pools is the sculptural base of an enormous strangler fig. This fabricated fig serves as a display rack for hundreds of the conservatory's bromeliads, but the nefarious story of its real-life counterpart deserves to be told.

This enormous plant starts as a small, innocent, epiphytic seedling, growing high in the rainforest canopy on the humus-rich branches of great trees. Searching for sustenance, it sends thin roots down to the soil. So far so good, but when the roots hit the ground and start absorbing water and nutrients, they thicken and wrap around the host tree, preventing the trunk from growing. The strangler

The ant plant, *Myrmecodia tuberosa*, has a swollen base full of caverns that provide housing for ants. In return, the ants protect the plant from other insect predators.

also grows an impressive canopy of leaves, further endangering the host by shading it from the sun. The unfortunate host eventually dies of starvation and rots while the victorious strangler lives on. Its lacy roots now rigid and strong, it stands in the forest like a tall tree with a hollow trunk.

But before condemning the murderous strangler for life, it is important to note that these plants are a keystone species of the rainforest. Their year-round supply of fruit is critical to the animals of the forest, and their latticed trunks provide countless nooks and crannies for critters to nest or hide in.

NEPENTHES: KILLING THEM SOFTLY The allure of the Asian pitcher plant, or *Nepenthes*, is unmistakable. With a brightly colored rim around its mouth and a teasingly half-open lid, the pendulous pitcher invites curiosity. But woe to the curious, be it insect or small animal, because one peek may well mean a slide into death.

Asian pitcher plants, *Nepenthes* spp., are vining carnivorous plants. Growing in areas where the soil is very poor, they trap living things in order to get needed nutrients.

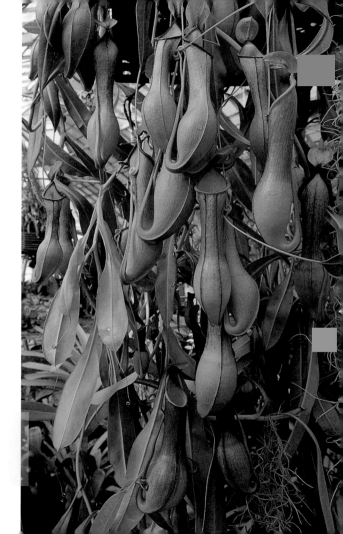

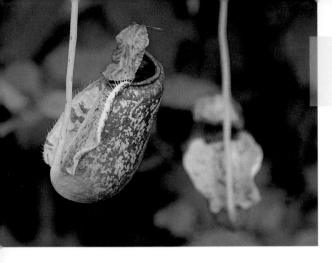

Nepenthes digest their prey in a liquid enzyme pooled at the bottom of their pitcher-like leaves. Some large species have even been known to consume small monkeys.

The Asian pitcher plant is a vining carnivorous plant and, like other flesh eaters, it must trap living things in order to get nutrients. Most carnivorous plants grow where the soil is poor, lacking in nutrients, or too acidic. Over thousands of years, they have evolved to make the best of a challenging situation.

Nepenthes trap their prey passively, relying on their color, shape, and the promise of nectar to lure in dinner. Animals and insects can walk easily on the pitcher's pretty rim, where they catch the scent of the sweet nectar just below or spy the possibility of a cool drink of water at the bottom. When they reach for it, a waxy surface sends most unsuspecting victims skiing into the pool below. This is no ordinary water. The liquid at the bottom of the pitcher is a digestive enzyme, and once in, creatures are not likely to get out: the interior waxy wall sports a mean set of downward-pointing hairs to ensure that even the most avid climber cannot escape. Struggling only makes it worse, as this encourages the plant to secrete more of the enzyme. Death by digestion soon comes. Something small, like a midge, is digested in a few hours. A fly might take up to two days.

The pitchers of most species grow to about six inches in length—the right size for feasting on insects. But some, like *Nepenthes truncata*, grow to as much as sixteen inches and have been known to consume rats, lizards, and even small monkeys. A growing heap of small bones and exoskeletons on the pitcher floor of an older, larger plant will attest to its egalitarian palate.

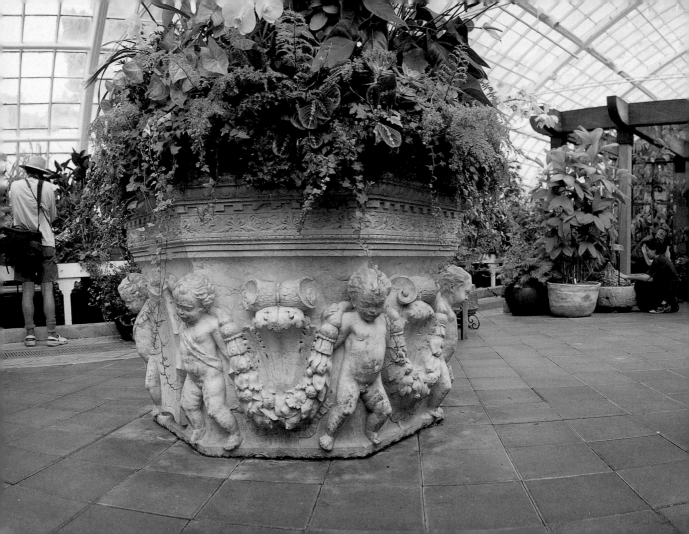

BOTANY WAS A VERY POPULAR SCIENCE IN the nineteenth century: Europeans and North Americans were simply possessed by the hunt for unusual plants, and they took up the practice of identifying, cataloguing, and pressing plants in droves. The same era also saw an unprecedented boom in the construction of greenhouses to hold large private and public collections of heat-loving tropical plants.

Territorial expansion was the name of the game during the Victorian era, and one of its enduring symbols is the exotic plant. Collected on daring adventures in far-flung corners of the world, tropical plants were among the most prized of the countless natural wonders and seemingly endless resources that were paraded home from the beleaguered tropics during this time.

European plant collectors had been making journeys into the tropics since the sixteenth century to gather seeds and spores, but the introduction of the Wardian case in 1827 started a revolution in the traffic of tropical plants. This portable forerunner

Potted Plants

The Potted Plants gallery recreates the atmosphere of a Victorian greenhouse and displays familiar species of tropical plants as well as many that aren't so well known.

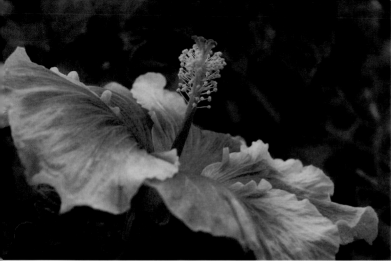

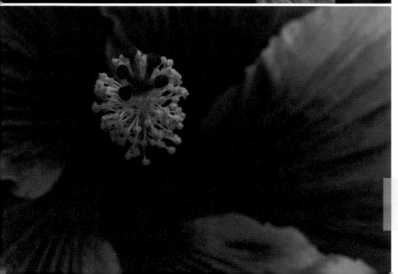

of the modern terrarium enabled collectors to successfully transport tender young plants and the more delicate species that ordinarily would have died on the journey home. Now an increasingly comfortable European and North American middle class could indulge its passion for subtropical gardening, the creation of a tropical-looking garden in a temperate climate. Plant fads began. There was fern madness, there was rhododendron hysteria, there was the coleus craze, and there were many others.

In England, the abolition of the glass tax in 1845 and the construction of the famed Crystal Palace in 1851 helped fuel the vogue for heated conservatories, and soon they were being added on to elegant homes across Europe and America. Entertaining in the conservatory was the height of fashion. Exotic orchids and carnivorous plants served as interesting conversation pieces for dinner parties and other social occasions.

A favorite with many a tropical gardener is the lovely hibiscus. Photographs by Holly Stewart.

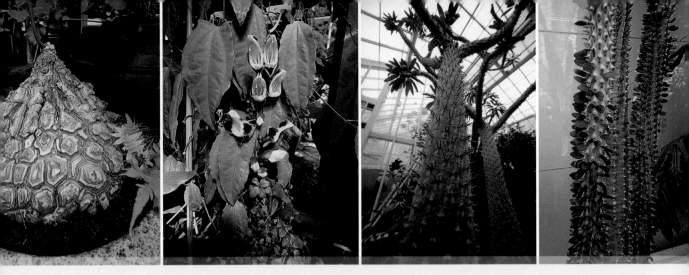

From left to right: The tortoise plant, *Dioscorea macrostachya,* has a distinctive swollen base that can be several feet wide. A wild yam, this plant is the original source for the birth control pill. The clock vine, *Thunbergia mysorensis,* is so named because it twists around its support in a clockwise motion. Thorns all over the trunk of the unusual Madagascar palm, *Pachypodium lamerei,* protect it from hungry animals. One of the primary members of the "spiny desert" community in the south of Madagascar, the Madagascar ocotillo, *Alluaudia procera,* grows leaves directly on its trunk. These will drop off at the start of the winter drought. The wood is often used for building houses and making charcoal.

The Victorians liked to rotate their plants in and out of the conservatory, continually freshening the display inside. They were also believers in the "more is better" approach to décor. So, ornamental pots and fancy furnishings were essential components of the nineteenth-century conservatory.

The Conservatory of Flowers applies this Victorian design principle to the Potted Plants gallery, where visitors will find, in addition to an always abundant assortment of hibiscus, begonias, coleus, and other tropical favorites to suit the season, an elegant wooden arbor, several decorative benches,

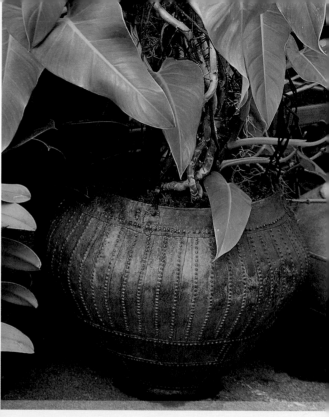

Left: Javanese palm pots are carved and hollowed by hand from black coconut trees. Above: These antique Gangalaya pots, made of brass and with handles shaped like parrot beaks, are of the type used to carry holy water from the Ganges River to temples.

and an extensive and valuable collection of containers. Several interesting vines, trees, and very unusual palms are permanently displayed here as well.

In a contemporary twist to the Victorian fascination with containers, the conservatory emphasizes the tropical countries where the plants on display originated: the majority of the beautiful urns and pots in this gallery were handcrafted by talented artisans around the globe.

The conservatory has a number of antique Gangalaya pots—lustrous brass vessels from Karnataka, India. With elaborate inscriptions and handles shaped like parrot beaks, these pots were traditionally used to carry holy water from the Ganges River to temples. Two elegant contemporary Javanese palm pots were carved and hollowed by hand from black coconut trees. Other containers hail from Burkina Faso, in Africa; the livestock farms of China; 1920s Guatemala; Brazil; Thailand; and Vietnam.

One notable exception to this tropical trend stands prominently in the center of the gallery— a restored Beaux Arts travertine plaster urn. This container is a legacy of the 1915 Panama-Pacific International Exposition, a historic San Francisco event that also gave the city its Palace of Fine Arts.

This restored Beaux Arts travertine plaster urn is a legacy of San Francisco's 1915 Panama-Pacific International Exposition.

For many visitors, the genteel atmosphere of the Potted Plants gallery, with its Victorian ambiance and abundance of tropical blooms, offers a pleasant conclusion to a trip to the conservatory. Throughout its history, the conservatory has presented special floral displays and gorgeous holiday spectacles. Potted Plants extends that tradition and celebrates the seasons with an ever-changing display of vibrant and fragrant blooms.

HEYDAY INSTITUTE

Since its founding in 1974, Heyday Books has occupied a unique niche in the publishing world, specializing in books that foster an understanding of California history, literature, art, environment, social issues, and culture. We are a 501(c)(3) nonprofit organization committed to providing a platform for writers, poets, artists, scholars, and storytellers who help keep California's diverse legacy alive.

We are grateful for the generous funding we've received for our publications and programs during the past year from various foundations and more than three hundred individuals. Major recent supporters include:

Anonymous; Anthony Andreas, Jr.; Arroyo Fund; Bay Tree Fund; California Association of Resource Conservation Districts; California Oak Foundation; Candelaria Fund; CANfit; Columbia Foundation; Colusa Indian Community Council; Wallace Alexander Gerbode Foundation; Richard & Rhoda Goldman Fund; Evelyn & Walter Haas, Jr. Fund; Walter & Elise Haas Fund; Hopland Band of Pomo Indians; James Irvine Foundation; Guy Lampard & Suzanne Badenhoop; Jeff Lustig; George Frederick Jewett Foundation; LEF Foundation; David Mas Masumoto; James McClatchy; Michael McCone; Gordon & Betty Moore Foundation; Morongo Band of Mission Indians; National Endowment for the Arts; National Park Service; Ed Penhoet; Rim of the World Interpretive Association; Riverside/San Bernardino County Indian Health; River Rock Casino; Alan Rosenus; John-Austin Saviano/Moore Foundation; Sandy Cold Shapero; Ernest & June Siva; L.J. Skaggs and Mary C. Skaggs Foundation; Swinerton Family Fund; Susan Swig Watkins; and the Harold & Alma White Memorial Fund.

For more information about Heyday Institute, our publications and programs, please visit our website at www.heydaybooks.com.